CONTROLLED FLIGHT INTO TERRAIN

CONTROLLED FLIGHT INTO TERRAIN

Stealworks Anthology 3.0

JOHN YATES

AK PRESS

EDINBURGH • LONDON • OAKLAND

FOR JEN: my greatest gift.

Love and thanks to those who matter. Bollocks to those who don't.

Printed in Canada.

ISBN 1-902593-67-7

Library of Congress Cataloging-in-Publication Data
A catalog record for this title is available from the Library of Congress.

British Library Cataloguing-in-Publication Data
A catalogue for this title is available from the British Library.

First published in 2003 by:
AK Press, 674-A 23rd Street, Oakland, CA 94612-1163, USA | www.akpress.org
For Europe:
AK Press, P.O. Box 12766, Edinburgh, EH8 9YE, Scotland | www.akuk.com

Contact John Yates/Stealworks directly at:
www.STEALWORKS.com

Designed & built by: John Yates at Stealworks ⊕
Copy editing & assistance by: Ramsey Kanaan, Jon Resh, the AK collective
Printed & bound by: Westcan Printing Group | www.westcanpg.com

Production Specs:
Contents produced on a G4 Apple Macintosh. All images scanned on an Epson Expression 636 or an HP ScanJet IIcx, then manipulated in Adobe Photoshop. Layout in Quark Express. Various EPS files created in Adobe Illustrator. Fueled by hot tea, bagels & cream cheese, rock & roll, anger, frustration, survival, hope, and love.

WHAT WE HAVE HERE IS AN ATTEMPT TO COMMUNICATE.

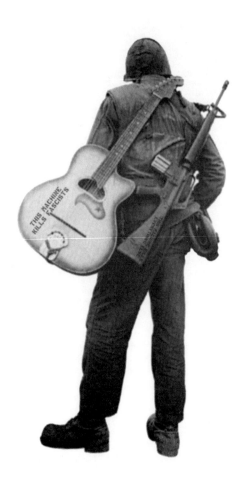

(MAL)CONTENTS

"In these dark days of punk bands selling shoes for venture capitalists and album artwork that looks like it was commissioned by whoever the idiots are who make Archie comics, it's nice to still have talented, passionate and thoroughly bleak blasphemers like John Yates around. Yates is to modern punk rock as the Piss Jesus is to the Vatican." —CHRIS H. (Propagandhi)

PREACHING TO THE CONVOLUTED

"Art is not a mirror to reflect society...but a hammer with which to shape it."
—BERTOLT BRECHT

"The reason I like to knock on doors is to find out who's home."
—Homeless person in conversation with author

These two quotes best describe the attitudes I hold toward my chosen field of visual protest. They serve well as metaphors for the underlying premise of my work — what I see as art's purpose within society, and for the act of asking questions. For those of us who feel we have no voice, this agit-prop provides amplification.

As for the doors? I like to knock on those that so often seem locked. They may be very big, intimidating doors, but they are capable of being rattled. My hammering may not register with those inside, but may well resonate with those like me, struggling to be heard. If enough of us are knocking at those doors, someone inside will eventually hear us. And they'll be forced to open them, if only to relieve the annoyance. But that's all it takes for those barriers to come down. Once the floodgates are open, there's no telling what might be inside. I for one would like to find out.

The title of this book has nothing directly to do with the events of 9/11. The title was chosen a few years back, around the time a pilot decided to fly his aircraft — and everyone on board — into the Atlantic Ocean from approximately 30,000 feet. 'Controlled flight into terrain' is the term used by the National Transport Safety Board for what amounts to pilot error. No other extenuating circumstances are found. Intentionally or unintenionally, the plane is simply flown into the ground.

Indirectly, the events of 9/11 gave the title a whole new meaning. What was intended as a cryptic swipe at the Bush administration's installation by the supreme court, became a very nasty commentary on US foreign policy in the wake of the September attacks. Suddenly, America became the passengers on a doomed flight. Bush and his Nixon/Ford/Reagan/Bush Sr. cronies were at the controls, and we were rapidly falling from cruising altitude.

But this isn't a book about aeronautical catastrophies. It's a book about electorial catastrophies, domestic and foreign policy catastrophies, market catastrophies, corporate catastrophies, environmental catastrophies, media catastrophies. It's a jumbo jet full of catastrophies, piloted by men with fewer flying hours than those who crashed into NYC, DC, and Pennsylvania. With an aircrew like that, who needs nineteen fanatical terrorists?

As I sit here punching keys, trying to find the words to explain my book's title, America is once again being herded toward war. It doesn't matter who we will be fighting, as long as we are fighting someone. And much like all other wars, few want this one, except those who stand to profit by it. Whether the profit is financial or political in nature — or both — those who engineer them always prosper. Meet the new war. Same as the old war. The perpetual war.

That said, I am not absolutely opposed to war. On the contrary, I would be an extremely vocal supporter of a war waged on poverty or AIDS, or in support of education, universal health care, or a host of other targets the state apparently cannot find the funds for. But when asked to pony-up the billions required daily to perpetuate death and destruction, suddenly the cash cow gets turned into prime rib.

But I'm not a politician. I'm not a cop. I'm not in the military. I'm a civilian. And that puts me at risk, because I am what is very comfortably referred to as "collateral damage" (in-waiting). It's friendly fire season in America, and the rank and file are considering their options.

It may well be the economy, stupid, but it's also the arms race, the oil industry, the corporate elite, and a bunch of egomaniacal and selfish men who cannot see beyond their lifetime, or term in office, for that matter. A mob of old money tyrants riding roughshod over those they purport to serve. If this really is the best America could come up with to pilot this nation, pass me a box cutter.

So here we are, terra firma-bound with a flight crew willing to commit the lives of countless others to satisfy their manias. And while the hawks will always prey on the doves, I'm ordering a double, reaching for the nearest parachute and going AWOL. Whether this particular parachute will provide a happy landing or not is for you to decide.

Kids in Kevlar hoodies

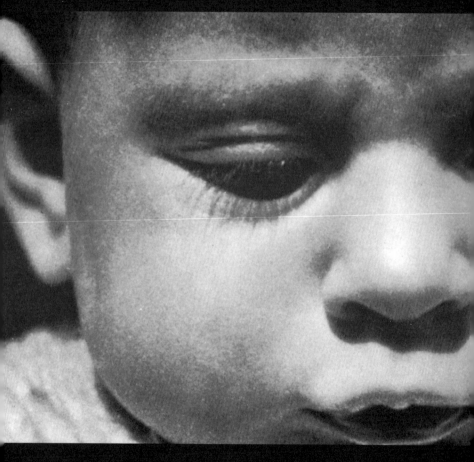

YOU ANNIHILATE

MY INNOCENCE

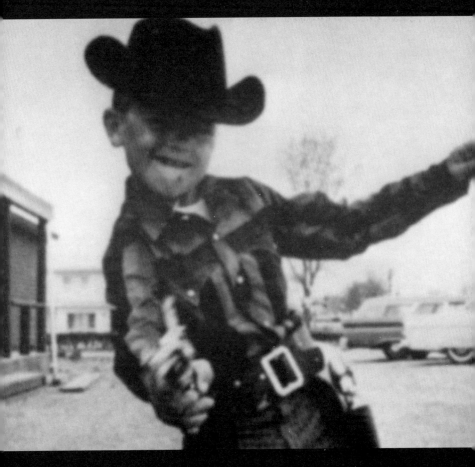

WHAT WE TEACH

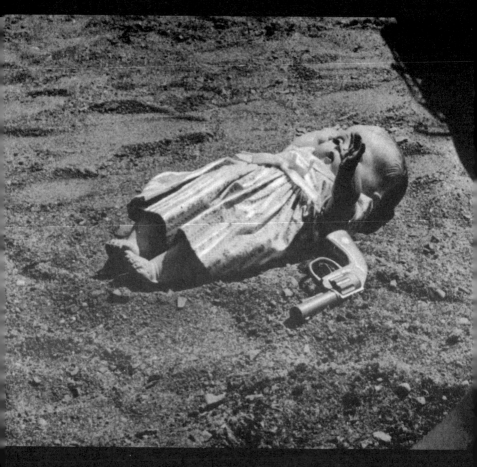

WILL HAUNT US

THEY HAVE IT ALL

WE TAKE IT AWAY

I WANT YOU

NOT TO KILL

SEE THEIR FACES

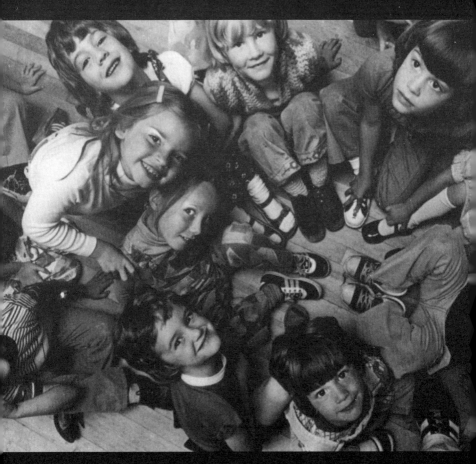

STOP YOUR WARS

LAYING FOUNDATIONS

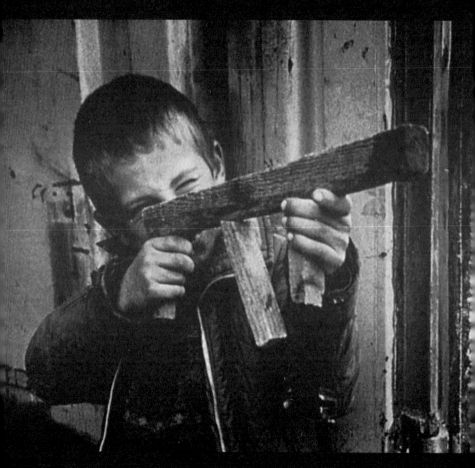

CONSTRUCTING HATE

Hawks & doves, bulls & bears,
and other insults to the
animal kingdom

STILL LIFE

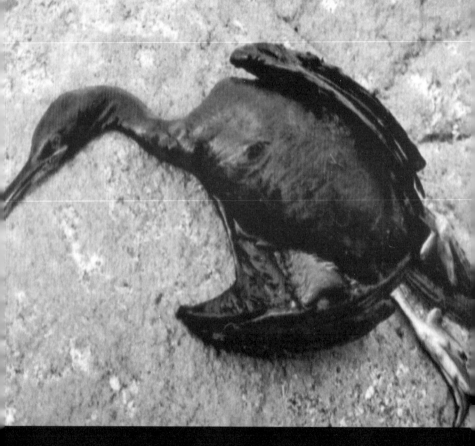

WITH OILS

DEFINE WEAPONS OF

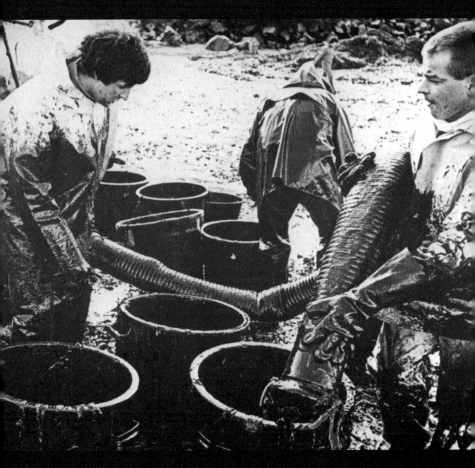

MASS DESTRUCTION

ONE PERSON'S PROFIT

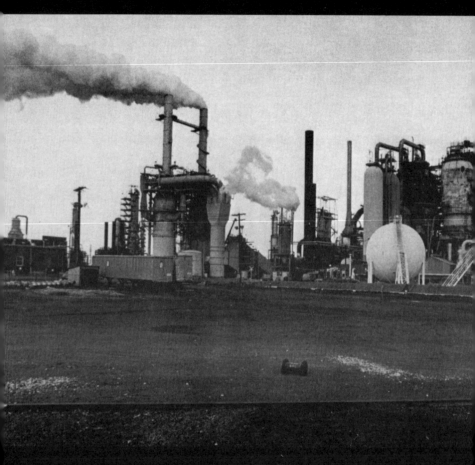

IS ANOTHER'S BREATH

OUR ENVIRONMENT'S

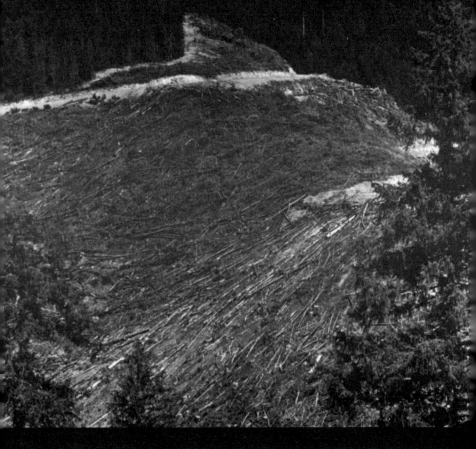

A TREE-RING CIRCUS

THEY CAN'T AFFORD

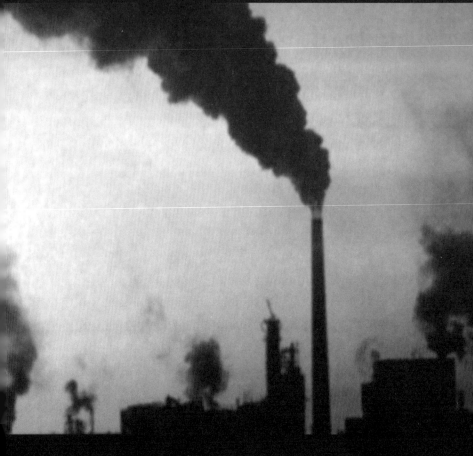

OUR CLEANER AIR

Before he discovered Christ,
he must've discovered Cruyff

GOD™

YOU USE IT LIKE A BRAND NAME

THOU SHALT NOT LIVE

BY SEPARATE RULES

YOUR HAIL MARYS

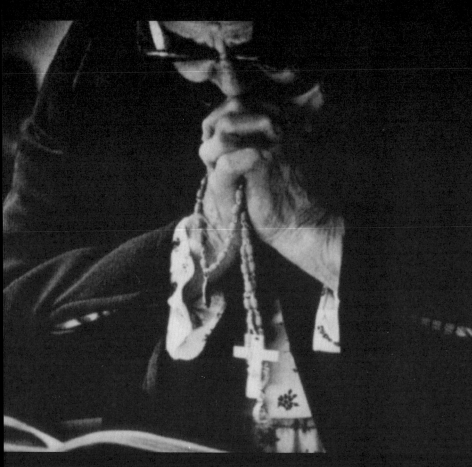

NO LONGER WASH

I GET RELIGION FOR

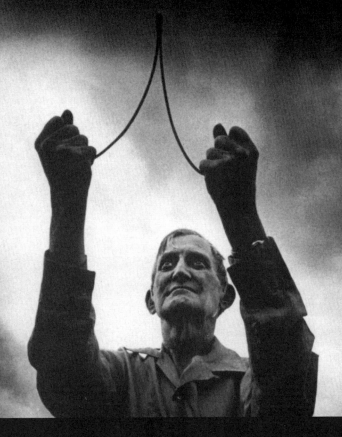

ZERO TOLERANCE

YOU LOOK GREAT IN

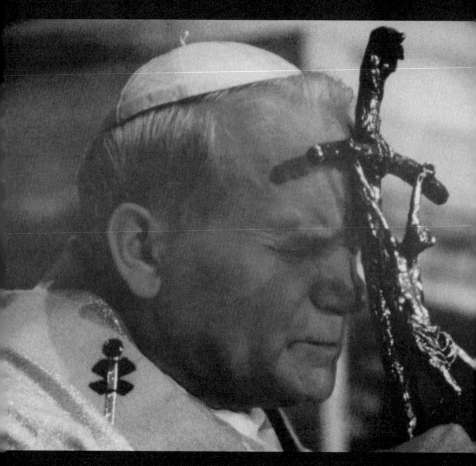

CARDINAL LAWSUITS

I ACCEPT YOUR FAITH

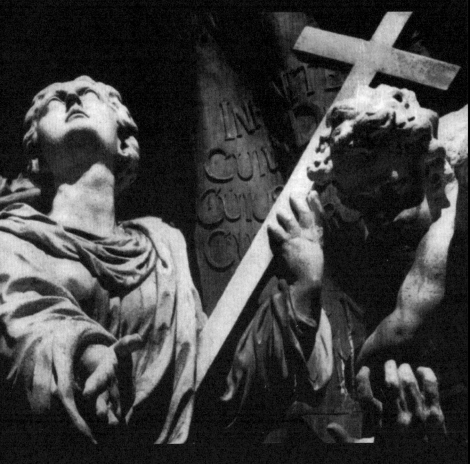

ACCEPT MY LACK OF

FAITH LIVES WITHIN

I AM NOT WITHOUT

Police and thieves in complete
state violence, state control

YOU ARE MY

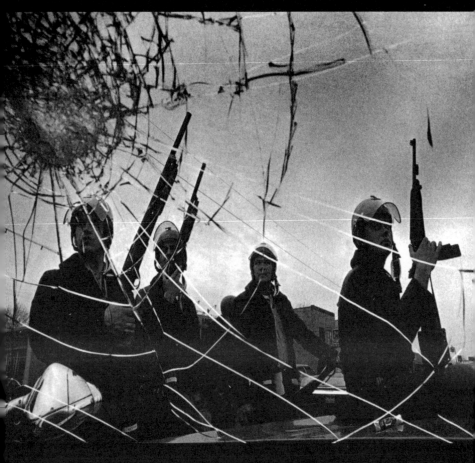

AXIS OF EVIL

STATE VIOLENCE

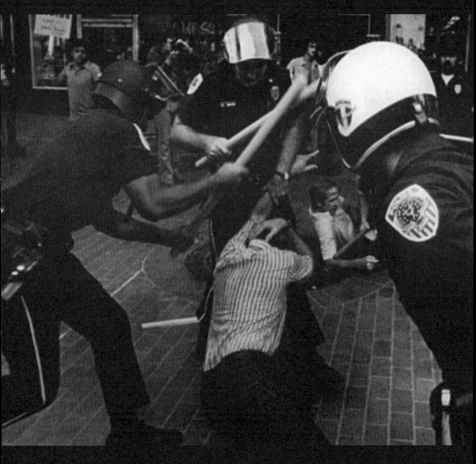

STATE CONTROL

YOU ARE SO PROUD

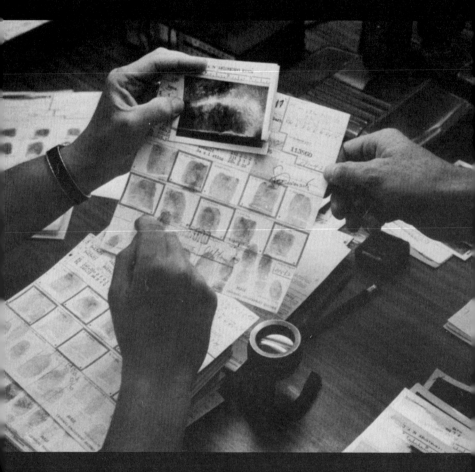

OF YOUR PROFILES

MAINTAINANCE WORK

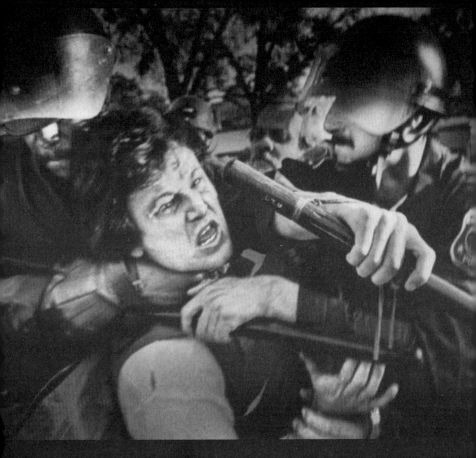

FOR THE STATUS QUO

WHY DO YOU SERVE

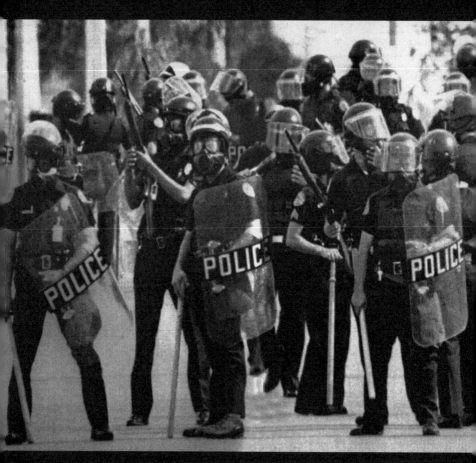

WHY DO YOU PROTECT

On being run down by the campaign
bandwagon, supreme courting,
and police state of the union

WE CAST OUR VOTE

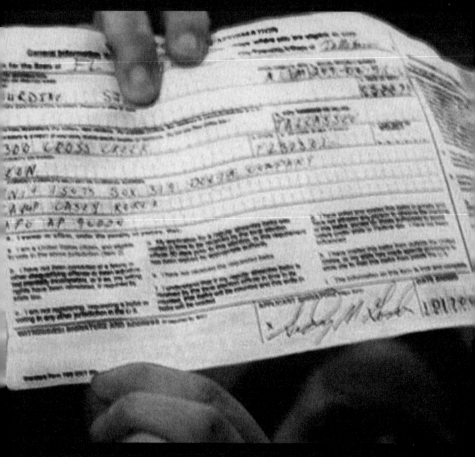

THEY CAST IT ASIDE

PREGNANT CHADS

NO ADMITTANCE

RIGHT TO CHOOSE

YOU ENSHRINE DEMOCRACY

WITH SUPREME HYPOCRISY

YOU PLAY POLITICS

WITH STATE POWER

TOO BUSY WAGING

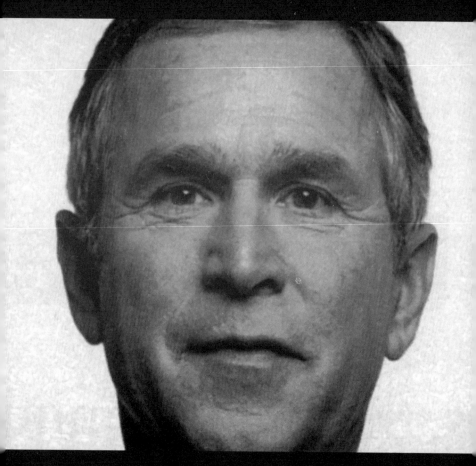

A WAR ON RATINGS

WHERE IS DICK?

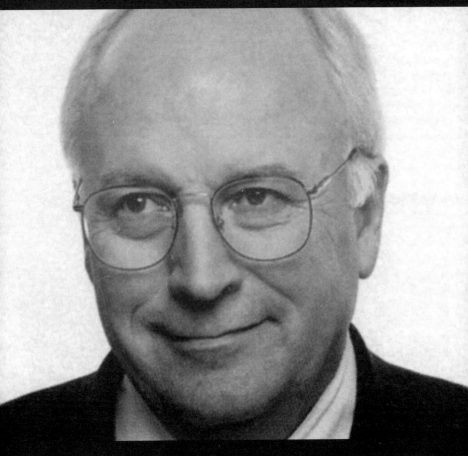

1-800-DICKLESS

MANIPULATE TRAGEDY

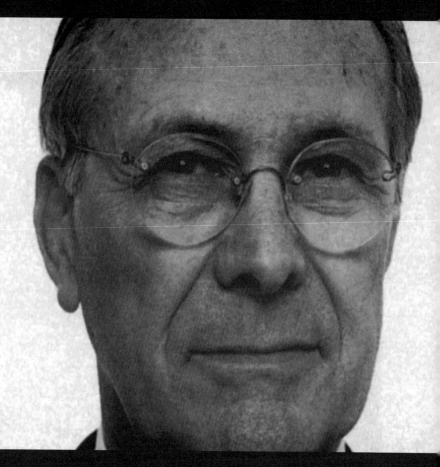

TO SERVE YOUR NEEDS

MAKING CELEBRATIONS

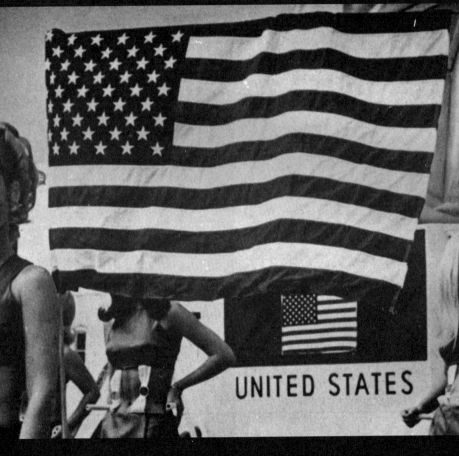

FROM PAIN AND MISERY

YOU'RE WAGING A WAR

LIBERTY CAN'T AFFORD

YOU FEATHER YOUR NEST

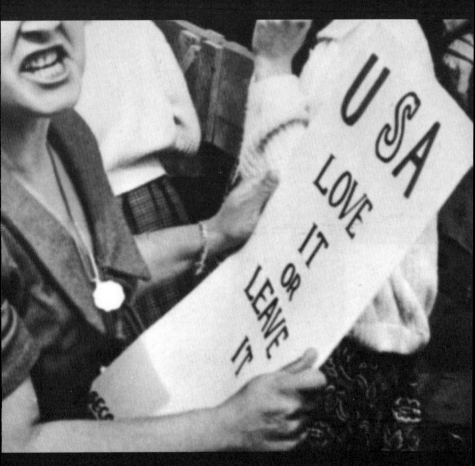

WITH HATE AND DIVISION

BUSY WAVING FLAGS

AND WAIVING RIGHTS

WE TROT OUT OUR

NERVOUS REFLEX

TAKING AMERICAN JOBS

AMERICANS WON'T TAKE

WE DEMAND

FOREIGN AID

I PASS ON THE RIGHT

YOU PASS ON THE LEFT

MONKEY BUSINESS IS

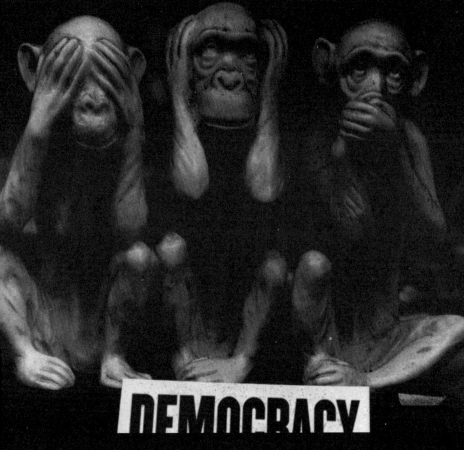

DEMOCRACY

YOUR MIDDLE NAME

TOO BUSY PARTYING

FOR OUR OWN GOOD

INSTEAD OF EQUALITY

YOU FOSTER DIVISION

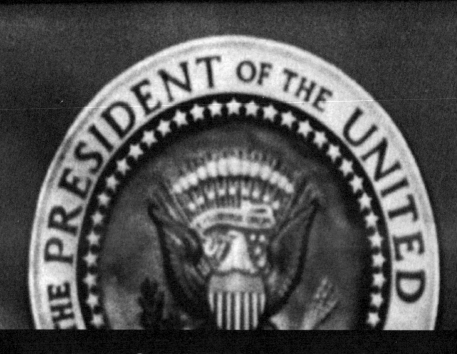

IT MAY BE YOUR SEAL

BUT NOT MY APPROVAL

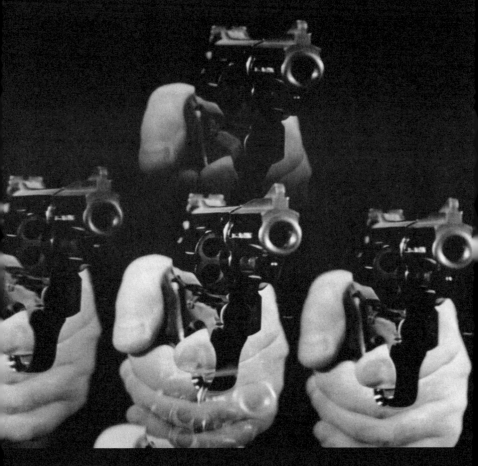

GUNS DON'T KILL PEOPLE

LIVING IN DENIAL DOES

THE BUSINESS END

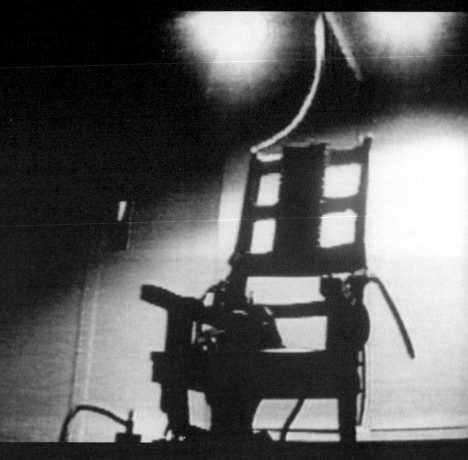

OF TRIAL AND ERROR

LEADING US DOWN

THE GARDEN PATH

CLOTH DISGUISES

YOUR INADEQUACY

Suppose they gave a war
and nobody complained?

THEY MILK TERROR

got war?

AND FEED OUR FEAR

IF WAR SOLVED ANYTHING

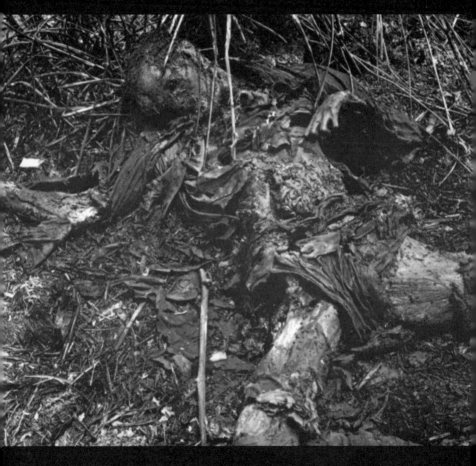

THERE WOULDN'T BE ANY

ROGUE NATION

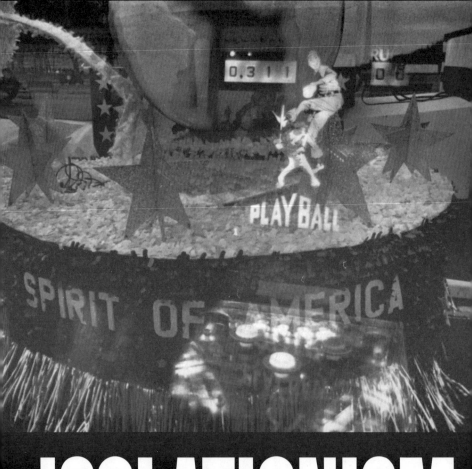

ISOLATIONISM

SUPPORT WARS

REMAIN SILENT

REMEMBER THE PAST

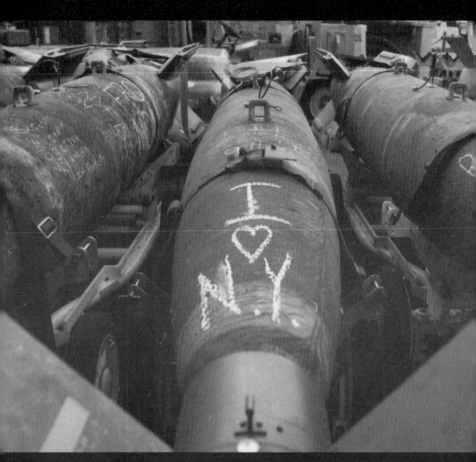

YET STILL REPEAT IT

BETTER LIVING THROUGH

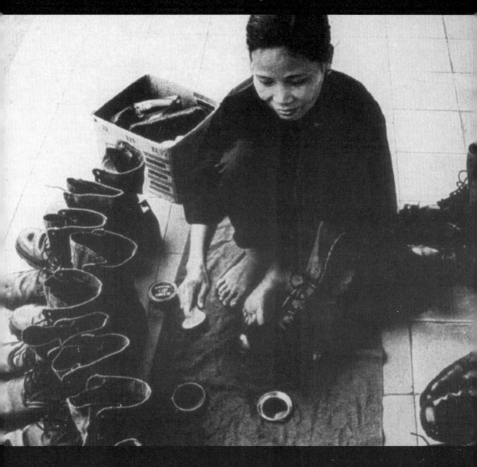

ENFORCED DEMOCRACY

SOLDIERS DIE

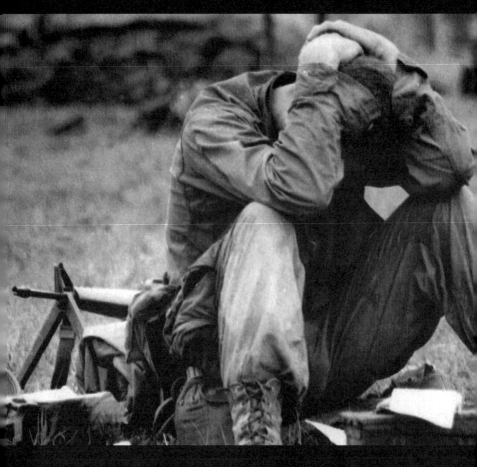

FOR YOUR SUV

DON'T FIGHT IN MY NAME

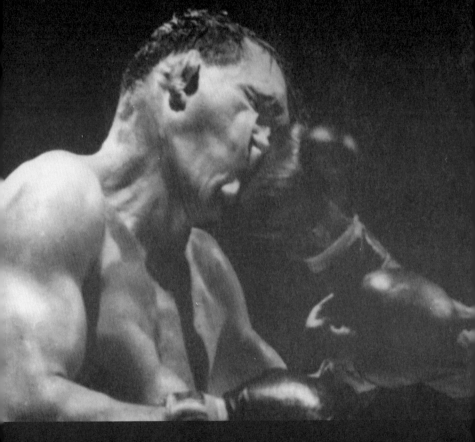

AND I WON'T DIE IN YOURS

SOME LIVE FOR IT

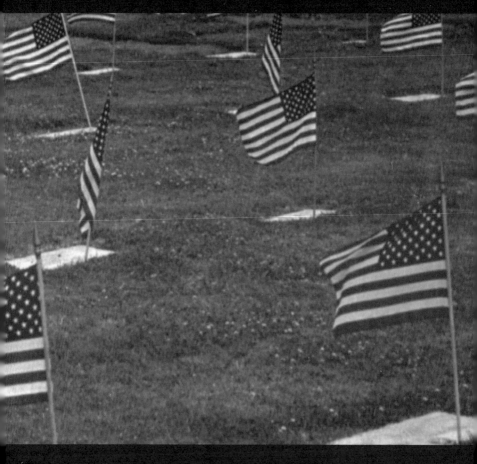

OTHERS DIE FOR IT

THEY DECLARE THEM

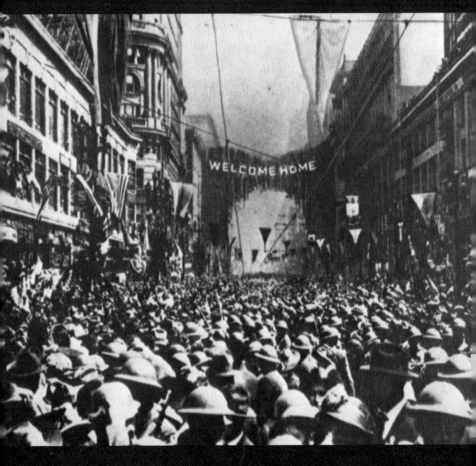

WELCOME HOME

BUT WE SUFFER THEM

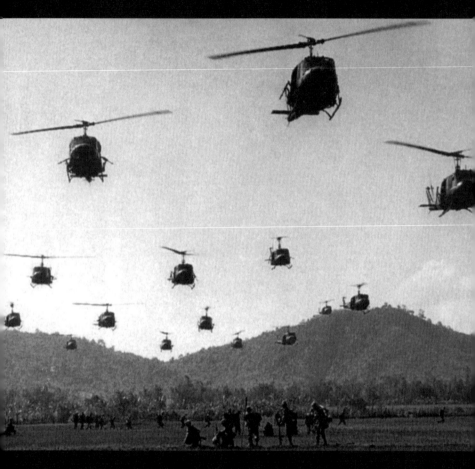

IF YOU LIKED VIETNAM

YOU'LL LOVE COLUMBIA

FOR EVERY FORTUNATE SON

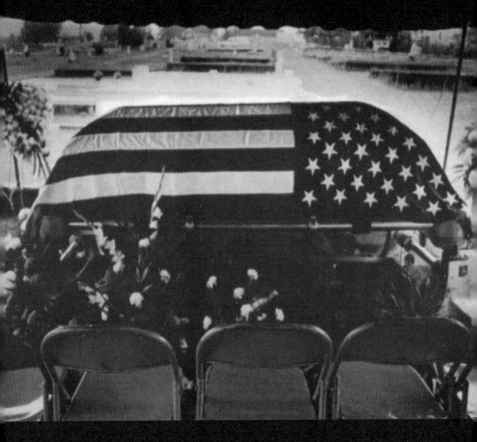

THE UNFORTUNATE ONES

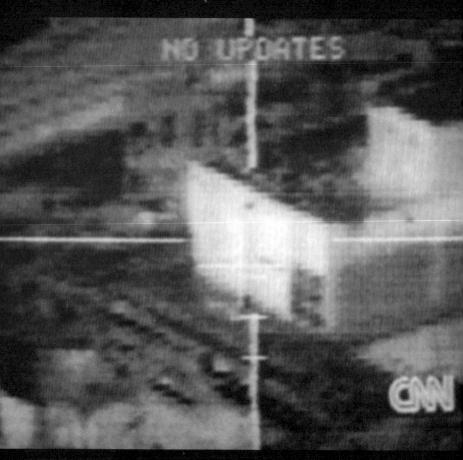

GET SICK OF RE-RUNS

NO UPDATES

CNN

CHANGE THE CHANNEL

IN THIS WAR OF TERROR

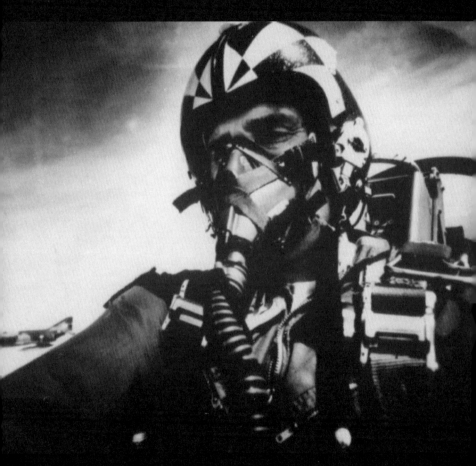

DEATH IS YOUR CO-PILOT

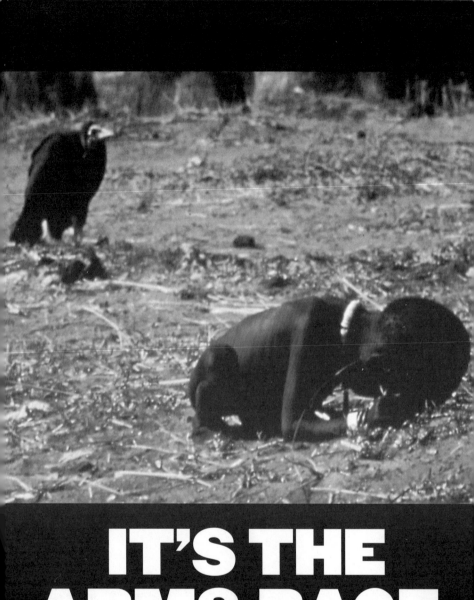

IT'S THE ARMS RACE, STUPID.

DEVELOPING NATIONS

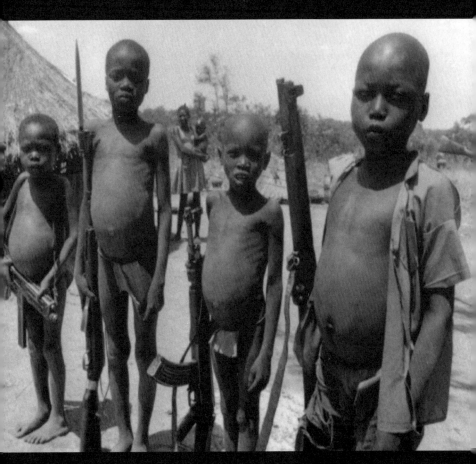

DO NOT MAKE ARMS

SMART BOMBS

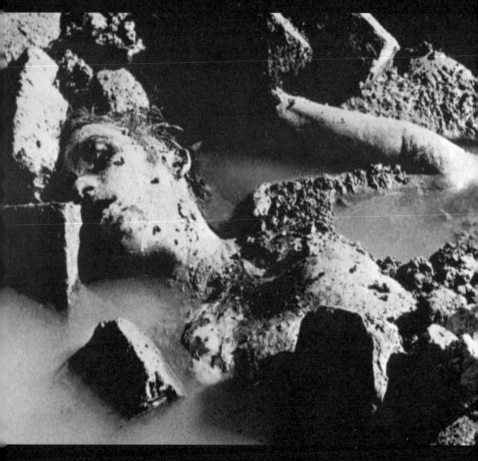

SOFT TARGETS

FAITH-BASED WARS

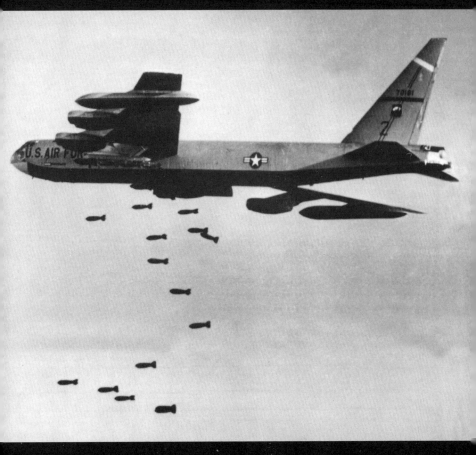

ARSENAL OF RIGHT

HEARTS AND MINDS

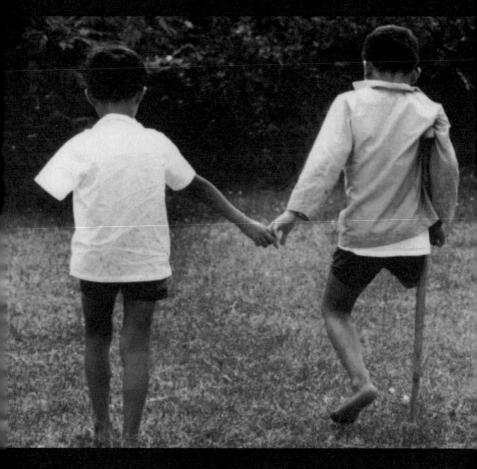

LIMBS AND MINES

PEACE IS A FACADE

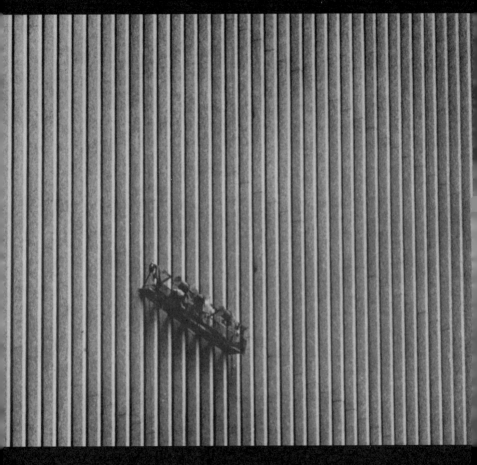

YOU BARELY TOUCH

YOU ARE

THE STATS

THAT DO NOT

APPEAR ON

PIE CHARTS

IN CORPORATE

AMERICA'S
BOARDROOMS

AN ARMY OF ONE

U.S. ARMY

You say you want a revolution,
well you know, we all want to
change the channel

LIFE'S A RIOT

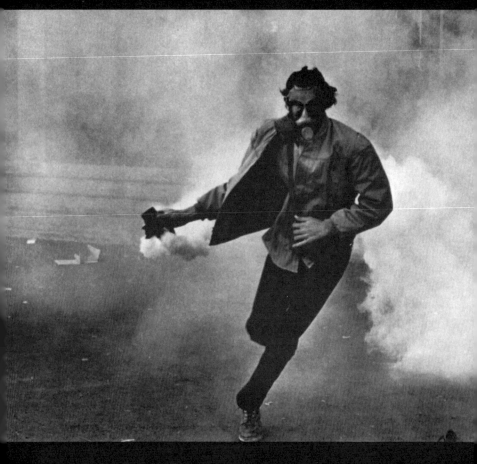

GET OUT MORE

YOU BETRAY IGNORANCE

WHEN YOU DISMISS US

YOU MUST REFUSE TO

BEG, STEAL OR FOLLOW

YOUR SILENCE IS

THEIR APPROVAL

WE REFUSE TO PLAY

YOUR LITTLE GAMES

IT BREAKS MY HEART

THE WAY YOU OPERATE

I LOSE MY BALANCE

WALKING YOUR LINE

YOUR SOLUTIONS

BREAK MY SPIRIT

YOU HAVE DESIGNS

WE CANNOT ACCEPT

YOU'RE SPOON FED

SPIT OR SWALLOW

FOR ALL YOUR DECEIT

WE SEE THROUGH YOU

DO YOUR PRISONS

MAKE YOU SECURE



YOU ACT SURPRISED

WHEN WE QUESTION

YOU GO TO GREAT HEIGHTS

TO SINK TO NEW LOWS

WE WANT SECURITY

YOU OFFER ANXIETY

Well, if that makes me
a communist...

WE'LL DO ANYTHING

FOR WHAT YOU HAVE

THE WORLD YOU MAKE

WE CAN NOT INHABIT

THEIR PLANS DEFINE

YOUR DESPERATION

WE TAKE OUR FEARS

INTO THE UNKNOWN

WE LIKE TO FOCUS

ON THE ARTIFICIAL

THEY SPEND LIFE

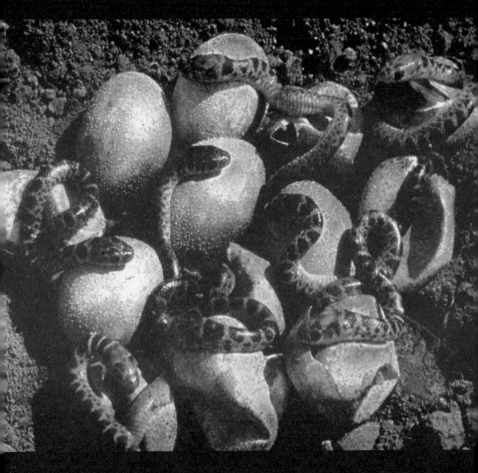

HATCHING PLOTS

MAINTAINING SECRETS

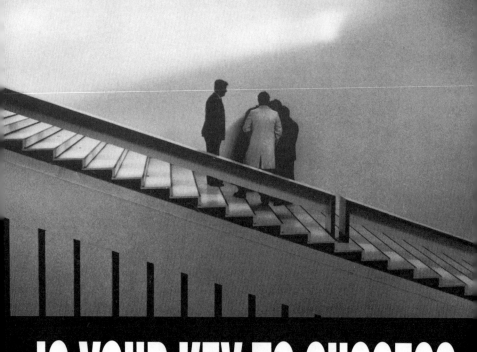

IS YOUR KEY TO SUCCESS

THE LINES ARE OPEN

WE DON'T TAKE CALLS

WHO'S VISION

DO YOU TRUST

WE WRESTLE DAILY

BUT THEY FLOOR US

YOU SELL YOUR SOUL

TO BUY THEIR DREAM

MONEY IS YOUR LIFE

BUT YOU DON'T LIVE

THEY HAVE MASTERED

FIRST IMPRESSIONS

NON-PRESCRIPTION

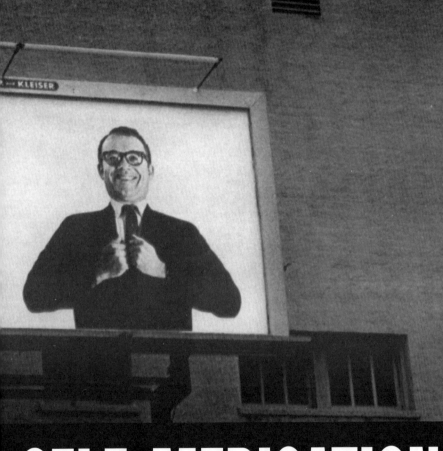

SELF-MEDICATION

ARE WE WORTH LESS

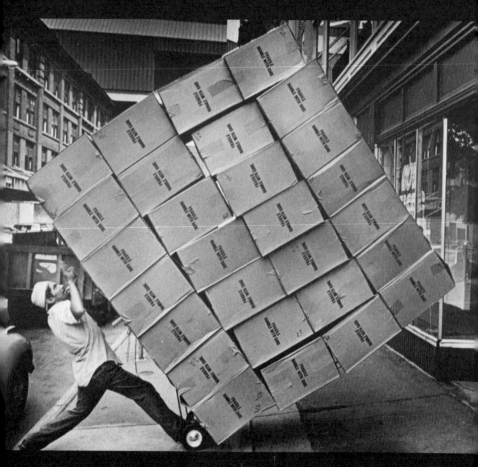

THAN WHAT WE OWN

SOMETIMES WE MISS

THE SIMPLEST THINGS

WE REFUSE TO BE

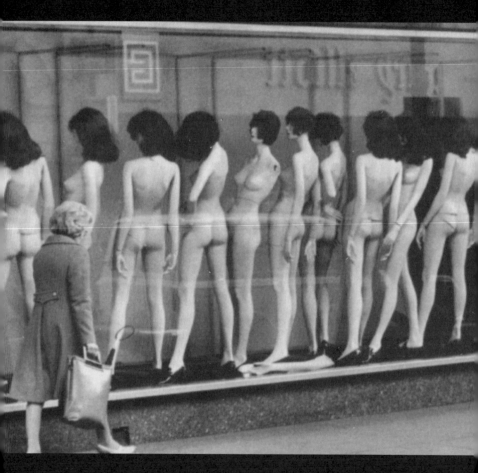

YOUR SPECTACLE

GRADUATE FROM THEIR

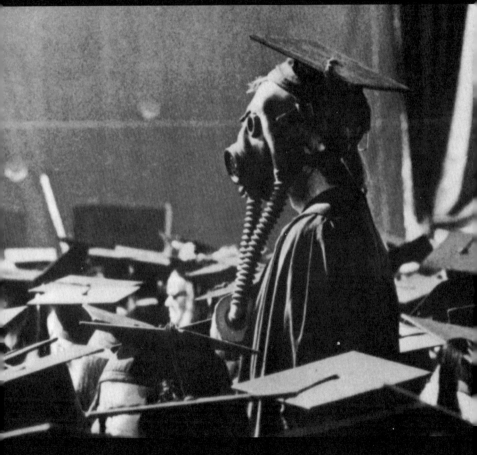

SCHOOLS OF THOUGHT

YOU ARE ON A SCHEDULE

YOU DON'T EVEN CREATE

WE TRADE AMAZEMENT

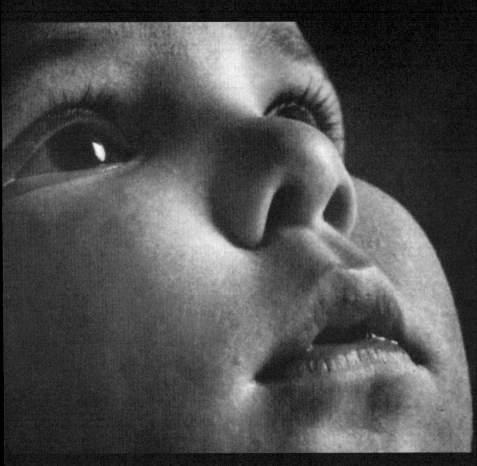

FOR PURE INDIFFERENCE

YOUR INTERNET

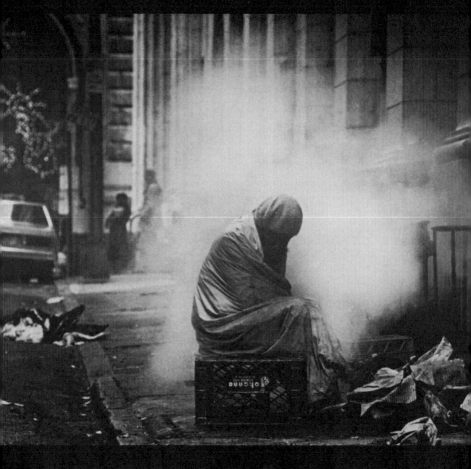

CHANGES LIVES

WHAT WILL YOU DO

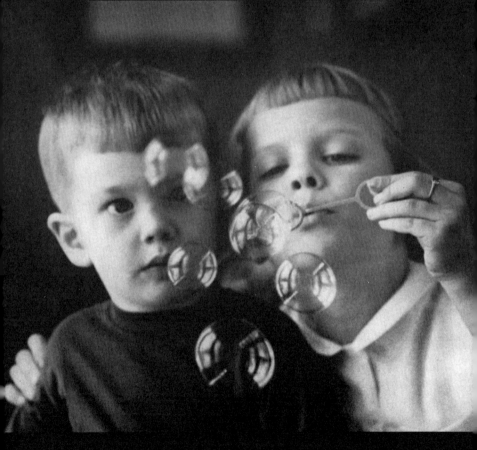

WHEN THEY BURST

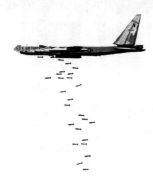

FIRST AID TO THE THIRD WORLD

FIRST STRIKE FOR THE THIRD WORLD

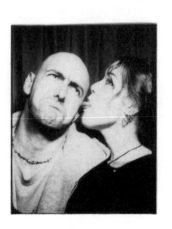

BIO(DEGRADABLE)

Born in Leeds, England, 1965. Eldest of two sons named after mother's Beatles favorites. Raised solo following father's capitulation of responsibilities. Aided and abetted by unabashed socialist grandfather. Is taught passion, independence, integrity, and that any working man who votes conservative should be put against a wall and shot. Excells in little at school but art, P.E., and in drawing the wrath of teachers. Chooses art over culinary school, surprising since he exists on cereal and toast. Attends because he finds it pays better than unemployment and there are no dress restrictions. Graduates two successive art schools with papers claiming him capable of design and photography. Stumbles into first design studio position. Spends next few years illustrating medical journals (poorly) and abusing free access to all manner of equipment, fueling first forays into music business design and zine publishing. Through mailorder purchases and persistent art submissions manages to hook-up with Jello Biafra through Alternative Tentacles' London office. Begins trading art via mail with Dead Kennedys' frontman. Is offered lyric booklet design job for DK's swansong album – first in over a decade of collaborative efforts with outspoken artist. Is offered a position at label's San Francisco office. Quits Thatcher's Britain, never looks back. Gives 10 years of visual skullduggery to pioneer label. Simultaneously runs D.I.Y. record label for 9 of those 10 years. Releases 100 titles, succeeds in goal of helping little-known bands become totally obscure. Creates various visual tirades against all manner of bad things, including small press items, posters, t-shirts, and the surprisingly popular 'Punchline' magazine. Freelances for numerous bands and labels, achieving modest name recognition in most industrialized nations, including Lichtenstein. Wrangles first book publishing deal through personal friendship leverage. Participates in several exhibitions, including fully funded trip to French international design show, courtesy of French arts council. Realizes he dislikes art shows. Sees designs appear on t-shirts internationally, highlighted by excellent product placement during 2000 Green Party convention and various anti-WTO protests. Remains a lifelong LUFC supporter, despite current season form. Resides in San Francisco Bay Area. Has a son and a long term relationship, both of which continue to enlighten, enrich, and enthrall him. Always receptive to design opportunities, interviews, and pie – pumpkin or apple.

AK PRESS

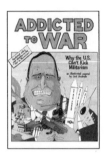

ADDICTED TO WAR: WHY THE U.S. CAN'T KICK MILITARISM
JOEL ANDREAS
AK Press I paperback I ISBN 1 902593 57 X I $8.00/£6.00

Addicted to War takes on the most active, powerful and destructive military in the world. Hard-hitting, carefully documented, and heavily illustrated, it reveals why the United States has been involved in more wars in recent years than any other country. Read *Addicted to War* to find out who benefits from these military adventures, who pays, and who dies.

"Political comics at its best. Bitterly amusing, lively and richly informative. For people of all ages who want to understand the link between U.S. militarism, foreign policy, and corporate greed at home and abroad." —MICHAEL PARENTI

"A witty and devastating portrait of U.S. military policy." —HOWARD ZINN

THE NEW WAR ON TERRORISM: FACT AND FICTION
NOAM CHOMSKY
AK Press/Alternative Tentacles I CD I ISBN 1 902593 62 6 I $14.98/£11.00

"We certainly want to reduce the level of terror...There is one easy way to do that...stop participating in it." —NOAM CHOMSKY, FROM THE CD

What is terrorism? And how can we reduce the likelihood of such crimes, whether they are against us, or against someone else? With his vintage flair, penetrating analysis, and ironic wit, Chomsky, in perhaps his most anticipated lecture ever — delivered a month after 9/11, and his first public statement — makes sense of a world apparently gone mad.

 ORDERING INFORMATION

AK Press 674-A 23rd Street, Oakland, CA 94612-1163, USA.
Phone: (510) 208-1700 I E-mail: akpress@akpress.org I URL: www.akpress.org
Please send all payments (checks, money orders or cash at your own risk) in US dollars.
Alternatively, we take VISA and MC.

AK Press PO Box 12766, Edinburgh, EH8 9YE, Scotland.
Phone: (0131) 555-5165 I E-mail: ak@akedin.demon.uk I URL: www.akuk.com
Please send all payments (cheques, money orders or cash at your own risk) in UK pounds.
Alternatively, we take credit cards.

For a dollar, a pound or a few IRCs, the same addresses would be delighted to provide you with the latest complete AK catalog, featuring several thousand books, pamphlets, zines, audio products and stylish apparel published & distributed by AK Press. Alternatively, check out our websites for the complete catalog, latest news and updates, events, and secure ordering.